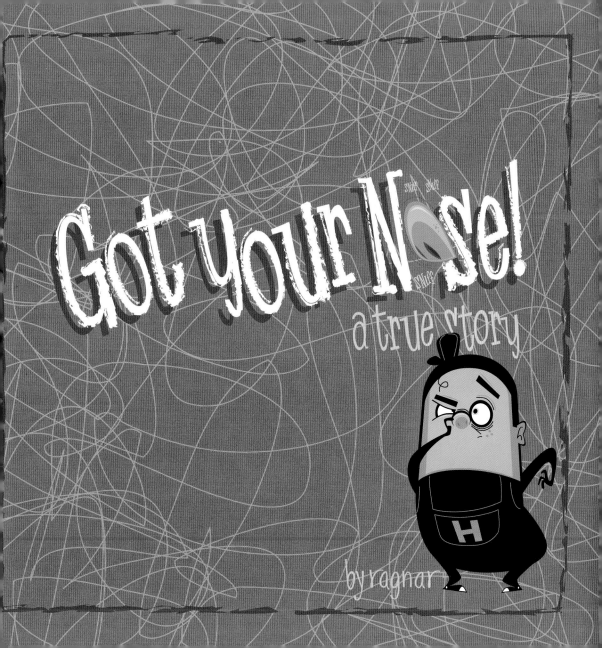

FOR OLIVER

Publisher reserves the right to discontinue the "99 $9 Books" series prior
to the publication of all 99 titles and/or to change the current suggested
retail price of $9.00.

ISBN 0-9729388-1-8
Library of Congress Control Number: 2003097619

First Edition
10 9 8 7 6 5 4 3 2 1

Published by Baby Tattoo Books
6045 Longridge Avenue
Van Nuys, California 91401
www.babytattoo.com

Manufactured in China

*Special Note to the Reader: The stunts and activities depicted in this book
are performed by professional cartoon characters for entertainment purposes
only and cannot, should not and/or must not be attempted by real people or
their pets.

Horace and Borris were brothers.

One was nice, one was not.

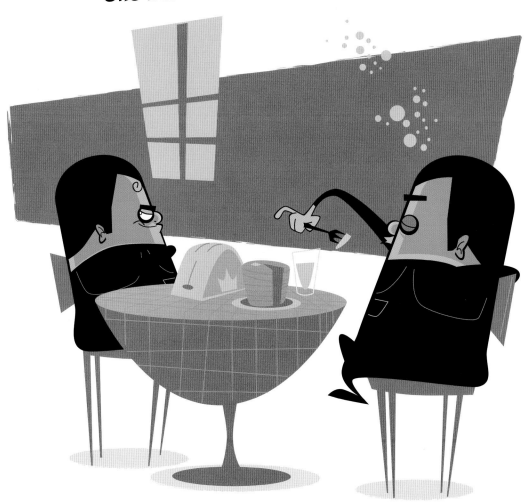

Horace was in a good mood this morning.

Whistling a sweet melody and enjoying a brisk walk.

His twin brother Borris didn't care for this.

Not at all.

And he was about to put a stop to it.

Just then...

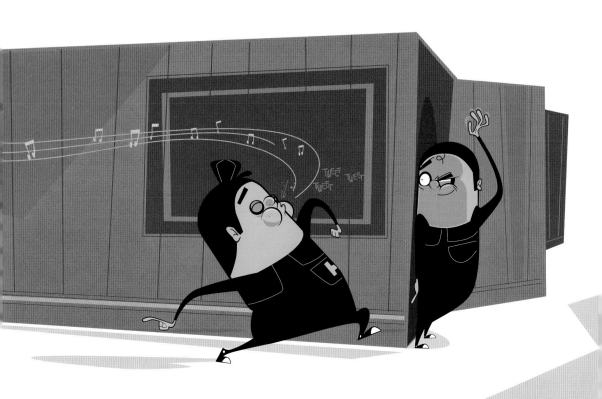

Borris jumped out and *snatched* Horace's nose right off his face.

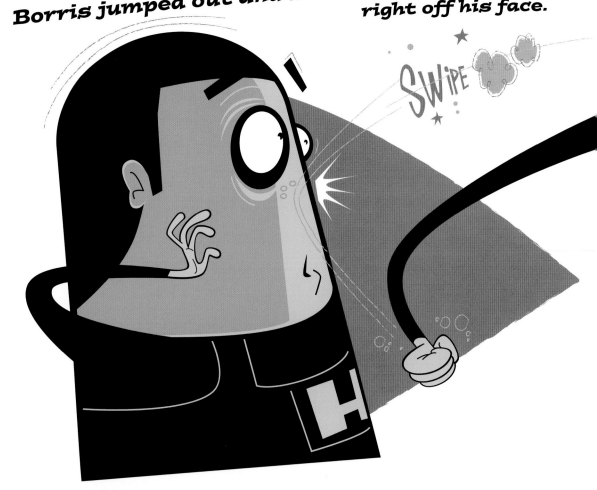

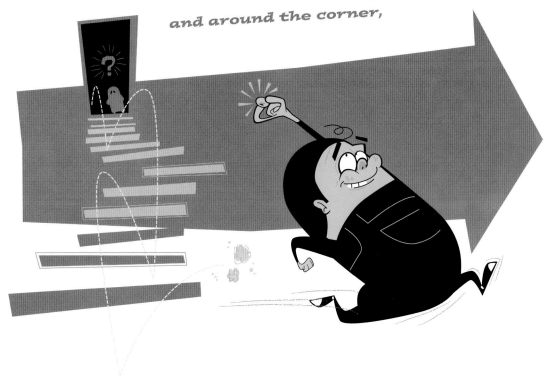

Before he knew it Borris was gone.

He was out of the house, down the street and around the corner,

Horace's nose gripped tightly in his sweaty, stinky hand. EWW!

Two blocks from home he joined
the Bellville marathon.

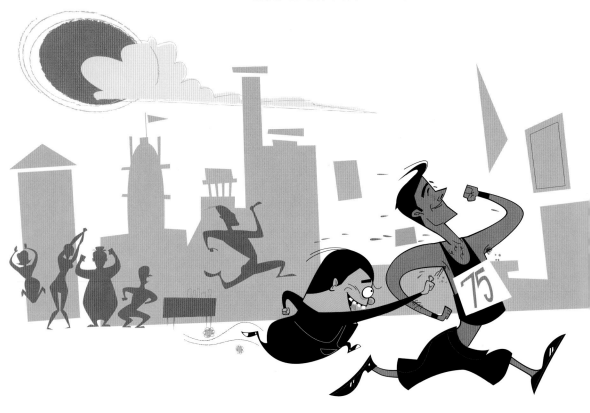

He came in 14th.

He followed every dog in town.

As well as a horse, two pigs, a flock of pigeons and even Uncle Clyde's pet goat!

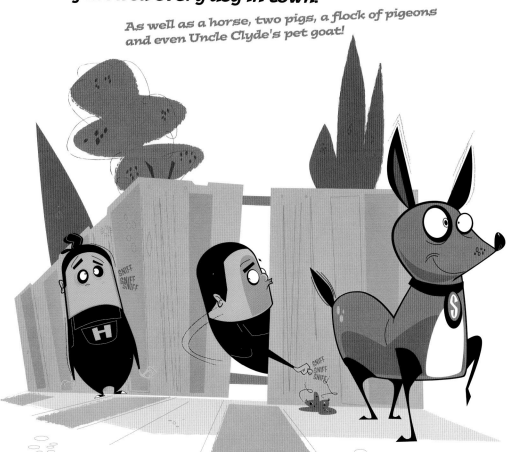

Borris stuffed the delicate little button into a hive of angry bees. *

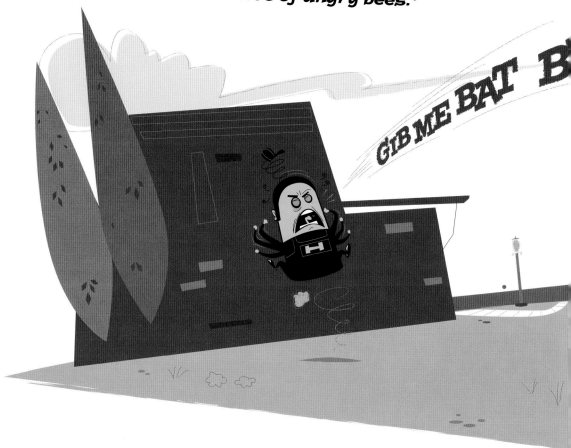

*The hive also included yellowjackets, wasps and even a few hungry ants.

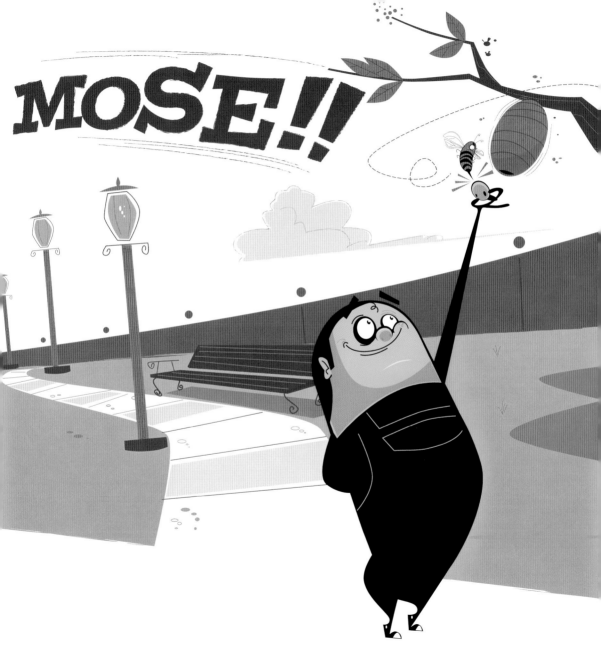

"You move one eyelash and in she goes."

Horace stopped in his tracks.

"Don't take another step **Borris hissed.**

Horace stood unblinking and silent

holding his breath.

then...

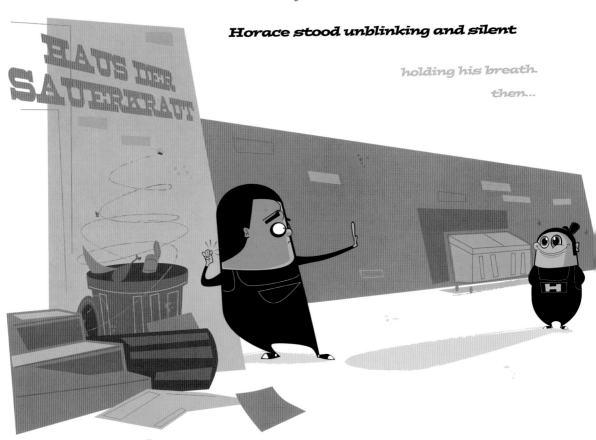

Borris did it!

He buried the nose in the smelly, greasy, overflowing trash can.

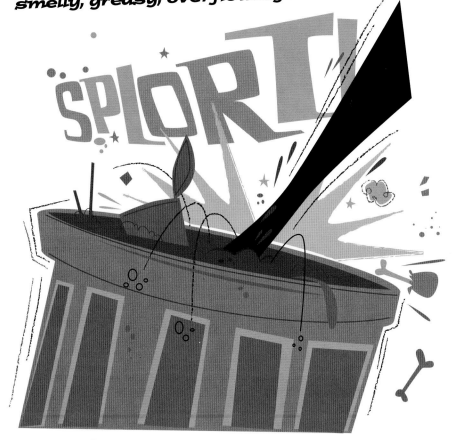

SPLORT!

Even though Horace hadn't budged an inch.

He ran down to the docks
where the firshermen unload their boats.
"How's 'bout a sniffer fulla sardine?"

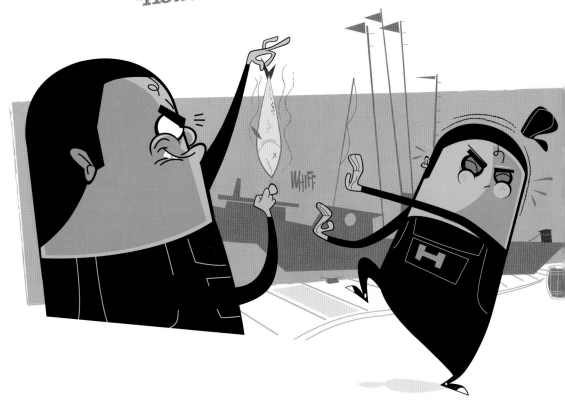

Horace didn't want a sniffer full of sardine

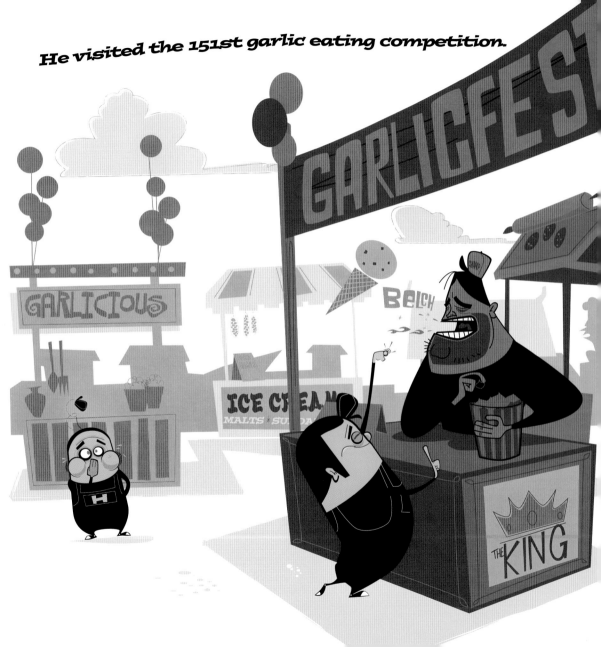

He visited the 151st garlic eating competition.

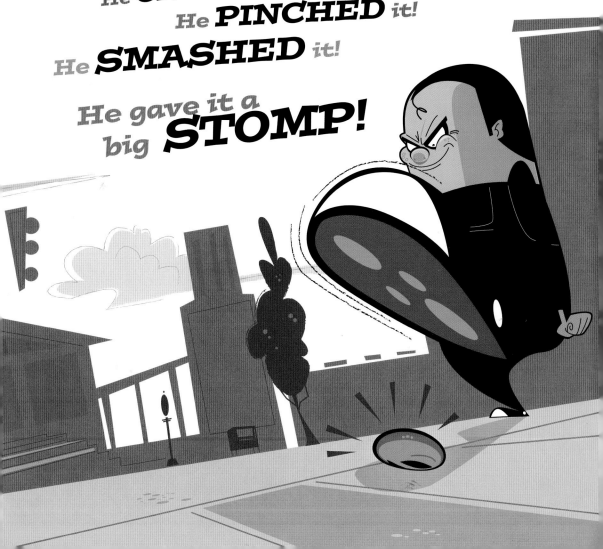

He held it under water. For a very long time.

And then a little longer

and then a little longer

and a little longer

and longer still.

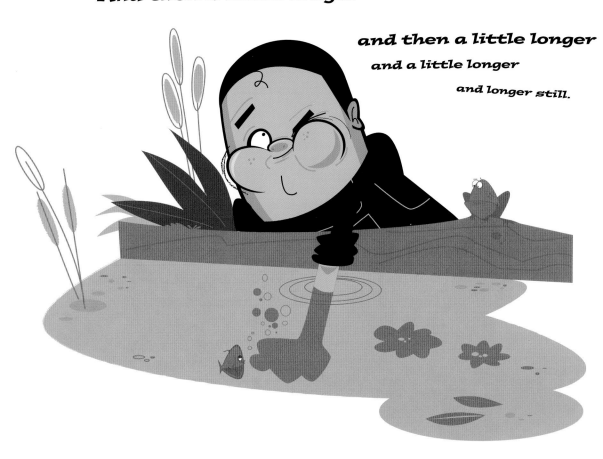

He threatened to dispatch of it by feeding it to the king of the jungle.

"I've got just the thing to soothe the savage beast."

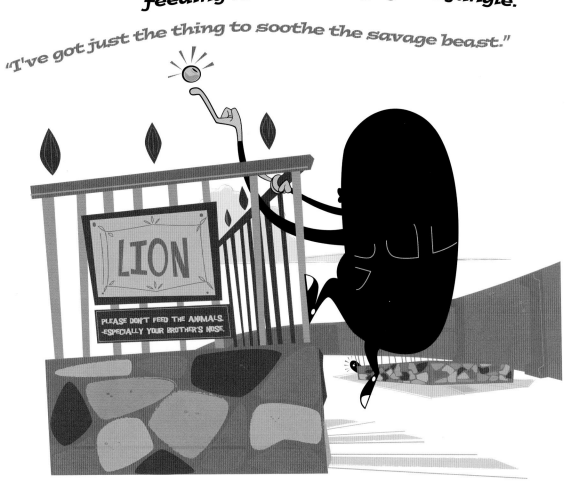

Borris never obeyed the rules.

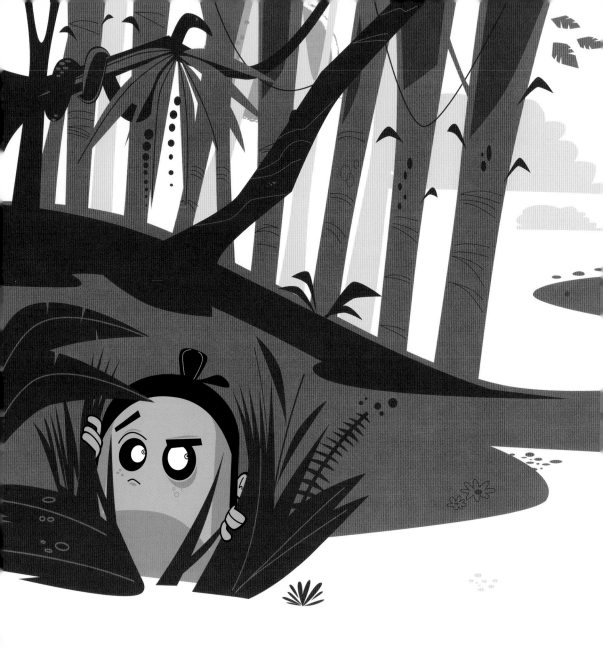

He traveled **7,658.3** miles to the very rare Stench Blossom.
(which blooms only once every century)

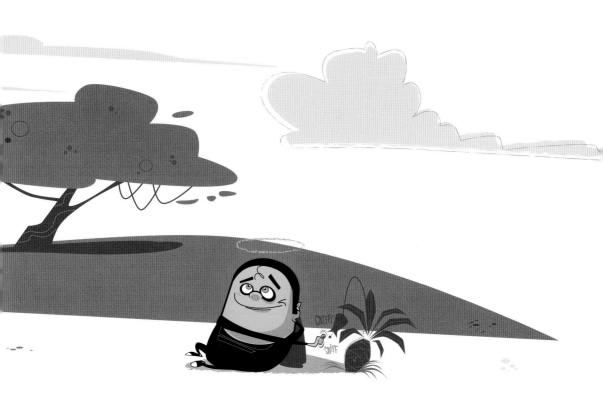

He attended the ACME company picnic.

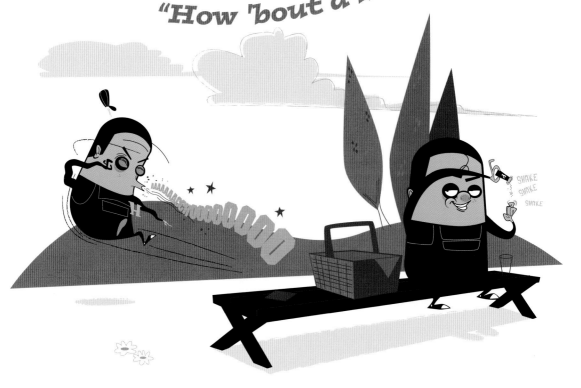

Borris did terrible, terrible things to Horace's nose.

"Remember what mom says about picking your nose!"

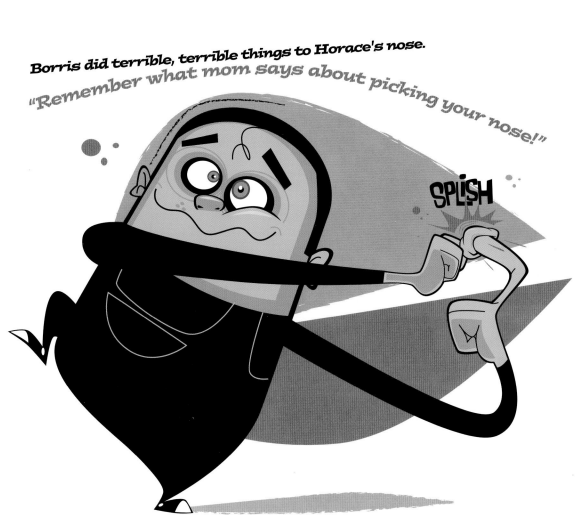

Then Borris did something so terrible, something so foul, something that Horace would never be able to forgive! **Not ever!**

He inflicted the worst abuse yet.

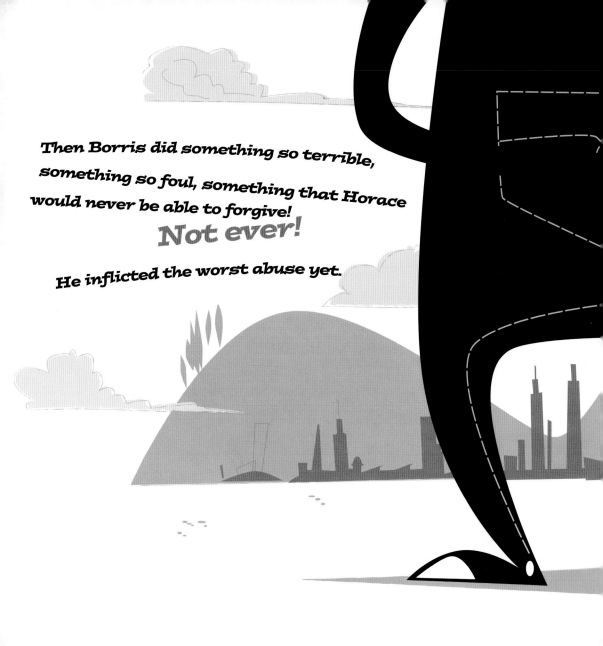

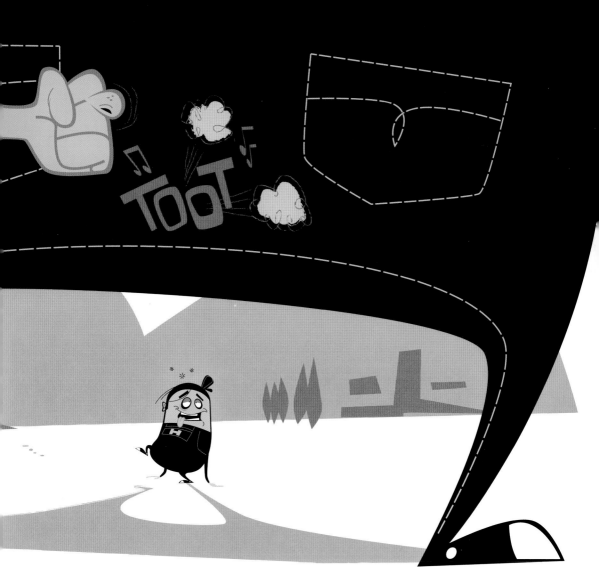

Borris laughed and laughed,
then he laughed some more
and when he couldn't laugh anymore, he did.

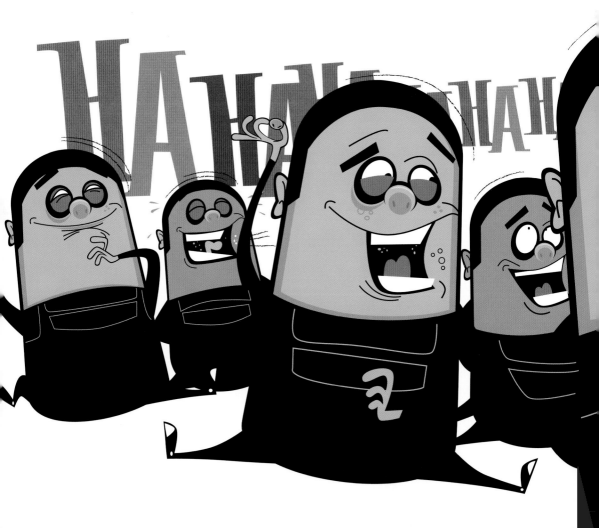

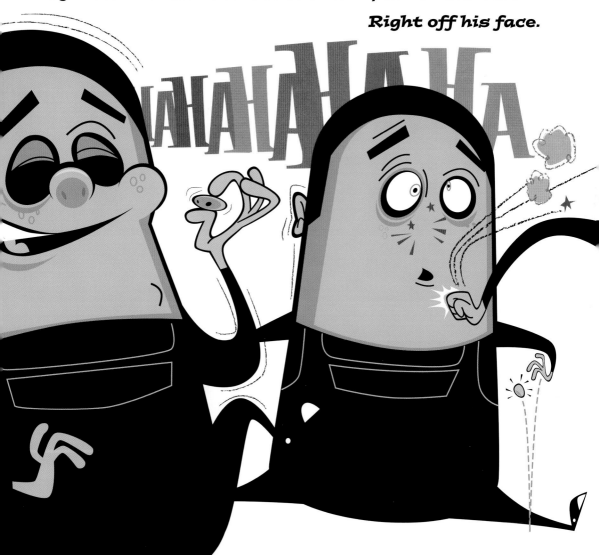

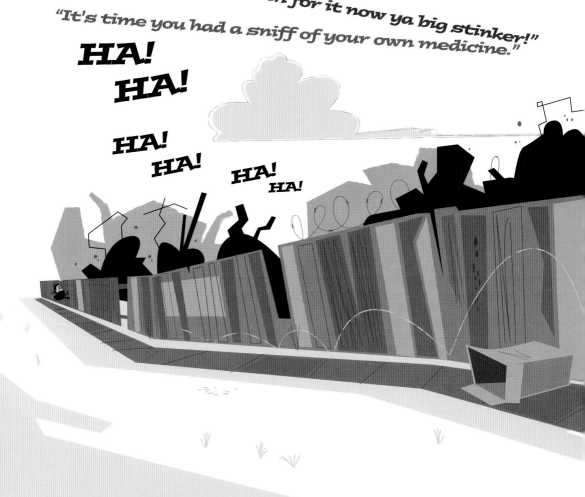

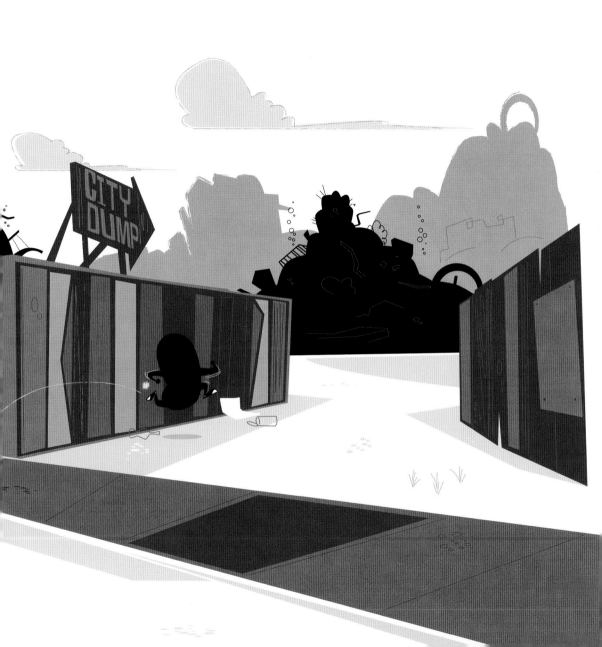

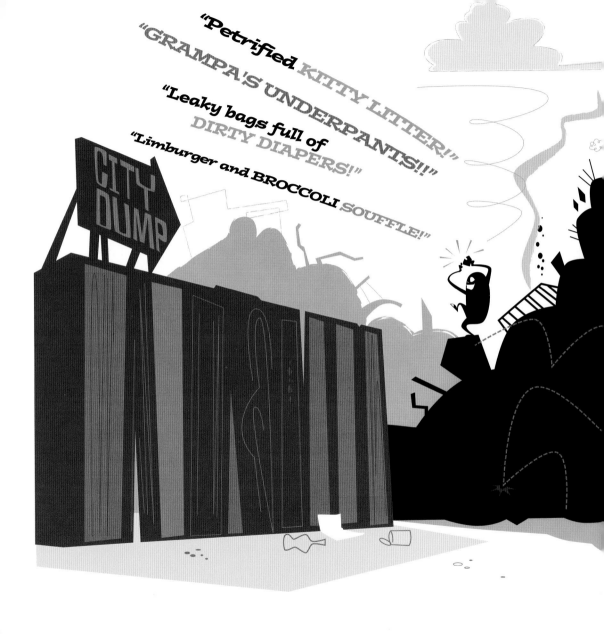

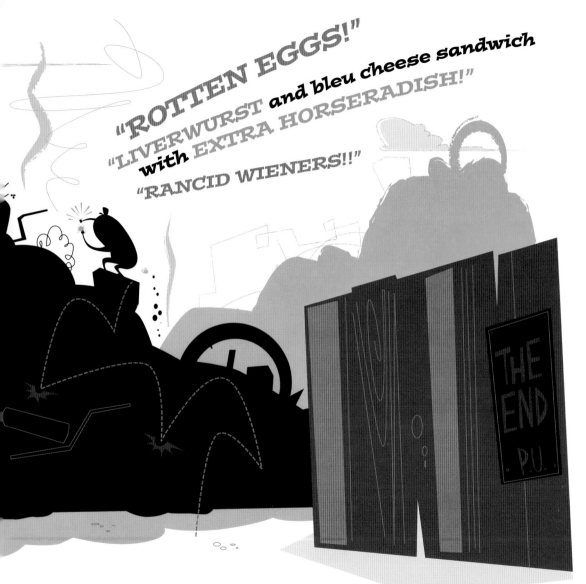

To this very day they're in that dump, engaged in the Ultimate Stinkoff.

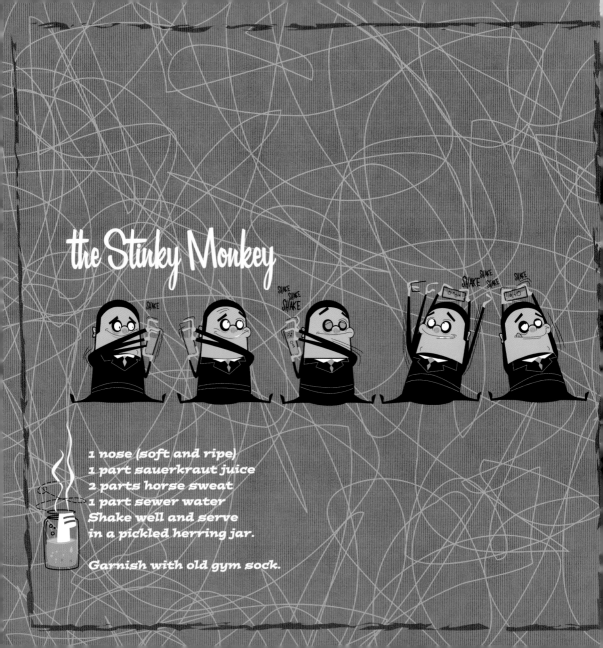